NARRATIVE IMAGERY

ARTISTS' PORTFOLIOS

NARRATIVE IMAGERY
ARTISTS' PORTFOLIOS

FLORENCE B. HELZEL

JUDAH L. MAGNES MUSEUM
BERKELEY, CALIFORNIA

This catalog is published
in conjunction with the exhibition
Narrative Imagery: Artists' Portfolios

Editor: Fronia W. Simpson
Design, composition, and production: Wilsted & Taylor
Typeface: Pegasus
Printing and binding: Malloy Lithographing, Inc.

Library of Congress Catalog Card Number: 90-063489
ISBN: 0-943376-46-7

Cover: Mordecai Ardon, *Rejoice ye with Jerusalem.*

For Deborah Lynn

CONTENTS

FOREWORD

Dr. Ernest Naményi, an eminent art historian specializing in the study of Jewish art, considered the continuous narrative in art to be the "great contribution of the Jewish genius to the art of the western world." He meant that Jewish art, like Jewish religion, expresses the process of becoming. As he explained in his book *The Essence of Jewish Art*: "In order to make an action understandable in its unfolding, one can not remain content with representing only an isolated scene. . . . It is therefore in a continued action, a true sign of divine reality, that we must seek the subject to be represented." The portfolio uniquely allows for both the development of a theme and the transmission of the full impact that a series of images can provide. It allows the artist to unfold a story, to interpret a biblical passage, or to present the full range of an experience or event.

As the first exhibit and catalog of its type, *Narrative Imagery: Artists' Portfolios* follows in the tradition of innovation and scholarship that characterizes the work of the Print and Drawing Department of the Magnes Museum and its curator, Florence Helzel. She has brought us to an appreciation of the significance and scope of the portfolio in Jewish art. We are grateful to her for the dedication she has given to this catalog. We are certain that it will be of lasting value to scholars and collectors alike.

Seymour Fromer
Director

PREFACE

Since 1982 I have been researching prints, drawings, and illustrated books at the Magnes Museum. Three major exhibitions have resulted from my work—the first on individual prints and drawings, the second on illustrated books, and the third on posters. This fourth project concentrates on yet another genre in our rich collections—the portfolio. I became interested in artists' portfolios when studying our illustrated books. Instead of harmonizing imagery with text as do the artists of illustrated books, many portfolio artists create imagery and tell a story without depending on a formal text. This catalog and exhibition focus on how they tell stories and the various stylistic methods they use to do so. Compared to the thousands of prints and hundreds of posters that are part of the museum's print and drawing department, the portfolio collection is modest. I have included the entire collection in this catalog and exhibition to demonstrate the breadth of themes and wide variety of styles by prominent, as well as less-known, Jewish artists, and by non-Jewish artists who chose to depict Jewish themes.

This catalog and exhibition have been realized with the caring assistance of many people. I especially thank Deborah Kirshman, fine arts editor, University of California Press, for her valuable suggestions; Fronia W. Simpson, for the fine editing of the manuscript; Christina Gleason, museum intern, summer 1990, for aid in research and in word processing; Alice Prager, for German translations; Ben Ailes for photography; Anita Noennig and her staff for portfolio conservation work; and Herbert Singer for matting the prints. My grateful thanks go as well to my colleagues at the Magnes Museum for their enthusiastic support of the project. To Jane Levy, librarian, Blumenthal Rare Book and Manuscript Library, for the major contribution of the Hermann Struck article; A. William Chayes, exhibition designer; and Paula Friedman, director of public relations, I extend my sincere appreciation. I am particularly indebted to the many donors who gave portfolios or provided funds to purchase them. Their support is essential for the continued growth and preservation of an important collection of art.

INTRODUCTION

Portfolios (also called suites or albums) in the Magnes Museum collection are composed of a series of prints that can be likened to chapters in a book. Varying in number from four to 135 in each portfolio, the prints are placed in boxed covers or wrappers, often displaying handsome designs by the artists. Because the majority of the portfolios are unbound, it is possible for individual prints to be removed and exhibited or studied close at hand. Unlike book illustrations, which ideally blend with text and often enhance it, images in the portfolios frequently create a narrative without benefit of the written word.

Portfolios are published in limited editions and created in a number of printmaking media, such as etchings, linocuts, woodcuts, lithographs, and screenprints, and reflect the styles of their artistic environment and time. Some of the portfolios have been commissioned by publishers, museums, and art dealers. While artists are often urged by publishers to produce portfolios, I believe that most of the artists represented in the Magnes Museum collection created these suites to express ideas they could not convey in a single work of art.

Creating works in a series is not a recent art form. It has a long history and was especially popular in eighteenth-century England. William Hogarth, for example, produced the moralizing, satirical sets of engravings that can be read like acts in a play, "Marriage à la Mode" and "The Rake's Progress." In nineteenth-century Spain, Francisco de Goya completed a series of etchings that are a devastating commentary on warfare, "The Disasters of War."

The early twentieth century witnessed a proliferation of portfolio art by the expressionists in Germany and by the School of Paris artists in France. The work of the expressionists displayed new forceful stylistic techniques of exaggerated gesture and dramatic contrasts of color, and after World War I the artists boldly commented on social and political movements. In Paris major artists of the avant-garde were commissioned to produce portfolios by the entrepreneur and publisher Ambroise Vollard, whose aim was to publish deluxe editions by painters who were not professional printmakers. It was Vollard who per-

suaded Chagall in 1931 to begin his Bible illustrations. This album of 105 etchings became a showcase for Chagall's brilliant artistry, interpretive skills, and innovative printmaking techniques.

In the Magnes portfolio collection, the narrative is the key ingredient in unifying the images. In virtually all of the portfolios, regardless of style or medium, the story prevails. Often the story is conveyed through the dominant image of the human figure. Through this form the artists interpret and mirror their feelings and events from their lives. They also comment on historical episodes and on traditional rituals of Judaism.

The earliest dated portfolio in the collection, *Scenes of Jewish Life*, 1884, originally published in 1723, attests to the extensive record and appeal of serial art. Picart's illustrations were part of an eleven-volume work on the ceremonies and religious customs of people all over the world, which was issued to subscribers in weekly parts.

The ten etchings in *Toward the End* by Sigmund Abeles were inspired by and begun during the last days of his father's life. Rendered in fine lines with sparse background, these realistic depictions of the aged and the dying record the emotional impact of a son watching the decline of a parent. They are a powerful reminder of the mortality of man. Abeles has continued to produce serial art, such as the sixty "Max" drawings of 1983 portraying his prematurely born son's struggle to survive.

Traveling on three continents and observing the fast-disappearing ghettos made a lasting impression on the Talmud-educated artist David Bekker. He drew ten individual scenes to describe rituals, legends, and personalities that gave Jewish ghetto life its distinctive character. Influenced by his own broad experiences, Bekker's portfolio of drypoint prints, *Two Worlds*, 1936, reflects this diarist's perceptions with humor and sensitivity.

Hermann Fechenbach and Walter Spitzer were eyewitnesses to atrocities committed during the Nazi era and felt compelled to document their experiences in a series of prints. While interned in Hutchinson's Camp on the Isle of Man in 1940, Fechenbach began *My Impressions as Refugee*, a group of twenty-one linocuts. These skillfully cut black-and-white prints portray the grim daily camp life in scenes of hunger strikes and tormented children. Fechenbach also lashes out at

his enemy by depicting the Nazi leaders in grotesque caricature studies.

Spitzer's life in Auschwitz was the background for the nine etchings of *Memory of the Shoah*. These shattering scenes of dehumanized man were so deeply embedded in the artist's consciousness that they became the impetus for his resolve to devote the rest of his career to the portrayal of Jewish themes of nostalgia and hope. Spitzer's *Shoah* series of 1955 is far removed from the brilliantly colored canvases of romanticized Jewish life that he paints today.

The suites by Sir William Rothenstein and Emil Orlik showcase the significance of portraiture in the portfolio collection. Their lithographs are distinguished by sharp insight, power of observation, and narrative undercurrents. Rothenstein's *Oxford Characters* provides a rare opportunity to glimpse a slice of history of a great university and to sense its vitality, diversity of activities, and scholarly achievements. From 1893 to 1896 Rothenstein was commissioned by the London publisher John Lane to draw twenty-four portraits of eminent professors and personalities connected with Oxford. Especially notable is the striking figure of David Margoliouth. Captured in an introspective pose and expertly articulated, Margoliouth epitomizes his accomplishments as professor of Arabic, author, and editor of the Arabic translation of Aristotle's *Poetics* in 1888. Rothenstein's portfolio also includes a portrait of Oxford-educated Sir Max Beerbohm, author and caricaturist. It was while a student in 1894 that Beerbohm published his first essays in the quarterly *The Yellow Book*.

Emil Orlik's *Pictures of Actors from Pandora's Box* from 1919 is a fascinating document of theatrical history, providing background material for the evolution of *Lulu*, a popular drama today. Published in 1904 by the German playwright and actor Frank Wedekind, *Pandora's Box* was later combined with his earlier work *Earth Spirit* and produced as *Lulu* in opera, film, and stage. Orlik's lithographs portray Werner Kraus, Gertrud Eysoldt, and the American-born Emil Jannings, the leading actors in *Pandora's Box*, in their specific roles. Their black-and-white figures are broadly outlined and convey psychological overtones characteristic of German expressionist art and the analytical probings of the author. These portraits are based on the 1918 staging of *Pandora's Box* in Berlin by the famous director and producer Max Reinhardt.

The sets and costumes, designed by Reinhardt's artistic adviser, Ernst Stern, remind us of the role Jews played in the creative arts in Germany and their assimilation into the mainstream of cultural life before the Nazi era.

The Jewish holidays have had a major impact on the art of Chaim Gross and Theo Tobiasse, inspiring them with a wealth of imaginative imagery. Gross's early family life in Eastern Europe, as part of a devout Hassidic sect, was focused on the Sabbath and the festivals that occurred throughout the year. The spirit and concepts of these celebrations became the foundation for his later values and ideals. His ten color lithographs in *The Jewish Holidays* follow the tone and feeling of both the most solemn and the most joyous rituals. Each holiday is treated as an autonomous composition, and the ten together become a compilation of beautifully composed short stories.

The travails in his life—an early childhood in Eastern Europe and a later two-year confinement in a Paris apartment during the Nazi occupation—left indelible marks on Theo Tobiasse. An overwhelming sense of freedom pervades his art, conditioning his imagery and sense of color. In his portfolio, arbitrarily proportioned figures, bursting with exuberant vitality and explosive colors, proclaim the festival of Shavuot. Adding to this rich visual experience is Tobiasse's printmaking technique of combining color lithography with carborundum etching (metallic powder mixed with resin) and embossing.

Spirituality, memory, and the striving for an expanded Jewishness are the driving forces of Tobiasse's creativity. It is an attitude he shares with many of the artists in this catalog. For these artists the portfolio has been a prime vehicle for narratives that recall the past and signify hope for a brighter future.

PORTRAITS AND CITYSCAPES
Two Portfolios by Hermann Struck

Hermann Struck (1876–1944) was an active figure in the German art world of the early twentieth century. He was a member of the Berlin Secession, a group of avant-garde artists, and, as an art critic, wrote a review of the 1909–10 Secession's print exhibition. Respected by his peers, he was elected to Britain's Royal Society of Painter-Etchers and Engravers in 1904, and a catalogue raisonné of his works was published in 1911. Extant correspondence gives evidence of his wide circle of friends, which included the philosopher Martin Buber, the psychoanalyst Sigmund Freud, and the writer Richard Beer-Hofmann. Struck was recognized as a leading authority on printmaking; his book, *The Art of Etching*, was published in five editions. Many important artists learned print techniques at his Berlin studio, including Marc Chagall, Max Liebermann, and Lovis Corinth. He also trained Jakob Steinhardt and Joseph Budko, who, as professors at Bezalel Academy, the Israeli national art school, trained a generation of Israeli printmakers.

Born into a well-to-do Berlin Jewish mercantile family, Struck made Judaism central to his life and artistic work. He was prominent in the Zionist movement as a leader in the religious Mizrachi party and was a director of the Keren Kayemeth, the Jewish National Fund. Struck kept kosher even in the officers' mess in the First World War and while traveling brought his own dishes and dried kosher meats. He frequently signed his work with his Hebrew name, Hayim Aaron ben David, or with a monogram of the Star of David and his initials. Karl Schwarz, a prominent art critic, said of Struck:

> *As an artist as well as a man he first is a Jew at all times, with a believing heart, which has experienced the severity and beauty of Judaism in its fullest. His belief, which expresses itself in a traditional way of life, permeates his entire being with a sunny cheerfulness, which combined with his artistic gift makes him the characteristic being that charms people.*[1]

[1]Karl Schwarz, *Jüdische Rundschau*, March 6, 1936.

Struck traveled extensively throughout his career, sketching the landscapes and architecture he encountered in Israel, Holland, England, Venice, and Switzerland. When he visited the United States in 1912, in addition to his artistic work, Struck helped reorganize the American branch of the Mizrachi movement and assisted with his first print exhibition in the United States at the Berlin Photographic Company, a gallery in New York. The artist returned to the United States in 1913, intending to travel from coast to coast creating an extensive American cycle, although he apparently never completed the trip. On both these visits, Struck encountered an energetic mercantile America, building its giant skyscrapers and factories. The artist was fascinated with the urban landscape of the United States. He felt skyscrapers, not yet numerous in Europe, were an American art form. His vision of the skyscraper, seen in Figure 1, was also articulated in an interview published in the *New York Times*. Struck said:

> You see, what interests me so tremendously in the skyscraper is the contour, the silhouette of these great buildings standing beside others and outlined against the sky. To me they then seem like our old castles on steep cliffs and mountain heights in the old lands of Europe. I do not care to see each window in such buildings nor to portray all the windows and other unimportant details in my sketches. It is the general impression that I want to catch and preserve.[2]

Struck was not alone in his admiration; many modern artists such as Max Weber, Louis Lozowick, Joseph Stella, and the early Georgia O'Keeffe also used the New York cityscape and the skyscraper as a theme for their work.

Amerikanische Reisebilder (American Travel Pictures), the result of his journeys, is an excellent composite portrait of the architecture and landscape in the rapidly industrializing United States, containing forty-four lithographs on Japan paper, each signed by the artist. Although the majority of the images are of New York, Struck includes land- and cityscapes of Washington, D.C., Boston, Philadelphia, and Chicago, as well as views of Niagara Falls, Florida, and even Cuba.

Portraits also form a significant part of Struck's artistic oeuvre. He created many likenesses of the leading artistic, literary, and scientific

[2]Hermann Struck, *New York Times*, January 26, 1913, sec. 5.

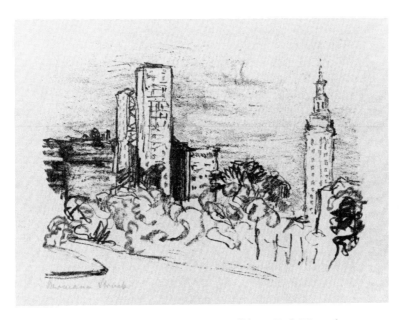

Figure 1. "New York: Blick auf Wolkenkratzer, II" (New York: View of a Skyscraper, II), from *Amerikanische Reisebilder.*

figures of his day, yet some of his most significant portraits are those of ordinary citizens, the *Ostjuden*, or East European Jews, completed during the First World War.

The *Ostjuden* became a German political issue in the 1880s because of the large-scale migrations into Germany following the pogroms in Russia. During the First World War, the issue assumed even greater importance. The war on the eastern front raged in heavily populated Jewish areas, accelerating the disintegration of Jewish village life. As more and more Eastern Jews moved to Germany, the differences between the form and substance of their lives and that of the Germans led to immense social and political problems within both the Jewish community and the German state.

The First World War was a pivotal experience for Struck, for he, like many other patriotic Germans, enlisted in the German Imperial Army. He first served as an interpreter stationed in Kaunas, a center of Jewish cultural activity in Lithuania. Later Struck was appointed head

of the Department of Jewish Affairs in the German military government. As department head, he tried "to convince the authorities that the Jew is a constructive element if his religious and national life are left unhampered."[3] Struck was effective in this position, reconciling Jewish and German interests. Moreover, he helped organize much-needed relief funds for the impoverished Jewish population. On the personal side, the artist loved the outdoor life at the Russian front and wrote to his mother, "Here the weather is mild. So I went for a wonderful walk to Tukum [a village west of Riga]. I took a small carriage also to return. I guess I never felt so healthy. Life in the midst of nature is the most beautiful I can imagine."[4]

Throughout the war Struck recorded his experiences in his sketchbook, learning about the East European Jews while drawing their portraits. Struck's close friend, the Zionist leader and author Sammy Gronemann, recalled a sketching session of Struck's at the eastern front: "I had become a sort of agent to catch the people who served as his models. And when I was able to draw out the handsome little beggar boy or the man with the box, who had been brought in, and to slowly overcome their mistrust I reaped a rich harvest. Once the shyness had melted away one could hear the true voice of the people."[5]

In the course of his duties as head of the Department of Jewish Affairs, Struck frequently saw the East European Jews. This direct participation in shtetl life helped shape his view of the Eastern Jew. Struck's nephew Henry Pachter related that the artist "discovered Eastern Jews, their mores, their speech, their physiognomies, their gait, their folklore, their worries. For the first time he drew Jews not because they were interesting or romantic, but as Jews who were part of a people."[6] The portraits reflect Struck's view that these poverty-stricken Jews reflected beauty, great sensitivity, and a hidden strength. For Struck, the Eastern Jews, such as the man in Figure 2, became a symbol of spirituality.

[3]Zosa Szajkowski, "The Komitee fuer den Osten and Zionism," *Herzl Yearbook* 7 (1971): 225–26.
[4]Struck to his mother, December 23, 1916, Hermann Struck Papers, Archives, Leo Baeck Institute, New York.
[5]Sammy Gronemann, "Erinnerungen eines Jecken," unpublished MS, Memoir Collection, Archives, Leo Baeck Institute, New York.
[6]Henry Pachter, *Weimar Etudes* (New York: Columbia University Press, 1982), 204.

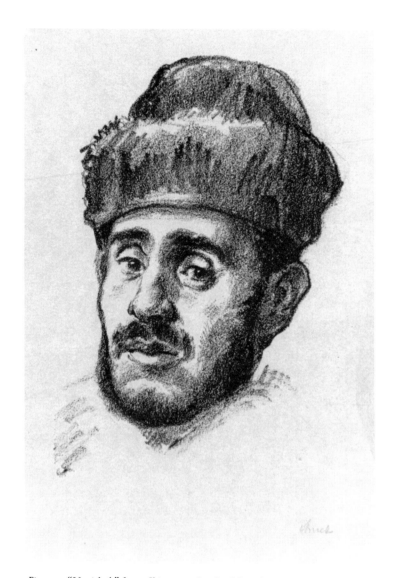

Figure 2. "Untitled," from *Skizzen aus Russland Ostjuden*.

Struck's *Ostjuden* portraits received widespread recognition in various published forms. During the war, a deluxe edition of the portfolio was published by the German military command, as *Skizzen aus Russland Ostjuden* (Sketches of Russian and Eastern Jews), probably under Struck's supervision. A less expensive edition was also published, and after the war smaller portfolios were issued by the Berlin publishing house Welt, containing four or five prints. The *Ostjuden* portfolio captivated Struck's friend, the novelist Arnold Zweig. In a review, Zweig said, "Struck never created anything superior,"[7] and the writer later collaborated with Struck to publish *Das ostjüdische Antlitz* (The East European Jewish Face). The book, comprising an essay by Zweig and Struck's *Ostjuden* lithographs, was first published in 1920 and was followed by a second edition in 1922.

Struck's *Ostjuden* portraits are a powerful narrative of the culture of East European Jewry. By presenting the *Ostjuden* as a positive force in Judaism, Struck's work helped reshape Western Jewry's response to East European Jews and helped to develop a wider interest in these people.

J. L.

[7] Arnold Zweig, "Struck 'Ostjuden,'" *Vossische Zeitung*, October 29, 1918.

[22]

Alte Juden (Old Jews). Berlin: Welt-Verlag, ca. 1920. 5 lithographs.

Amerika (America). Berlin: K. Voegels, 1922. 20 etchings, with a foreword by Arthur Holitscher.

**Amerikanische Reisebilder* (American Travel Pictures). Berlin: Tillgner, 1922. 44 lithographs in an edition of 45.

Gaonim [Heads of Talmudic Academies]. Berlin: Welt-Verlag, ca. 1920. 6 lithographs.

In russisch Polen: Ein Kriegstagebuch (In Russian Poland: A War Diary). Berlin: J. Bard, 1915. 23 lithographs in an edition of 300.

Jehudim (Jews). Berlin: Welt-Verlag, ca. 1920. 5 lithographs.

Jüdische Arbeit (Jewish Labor). Berlin: Welt-Verlag, ca. 1920. 5 lithographs.

Land of Israel. Frankfurt am Main. 25 etchings in an edition of 100.

Ostjüdische Frauen (East European Jewish Women). Berlin: Welt-Verlag, ca. 1920. 5 lithographs.

Ostjüdische Jungen (East European Jewish Lads). Berlin: Welt-Verlag, ca. 1920. 4 lithographs.

Ostjüdische Typen (Typical East European Jews). Berlin: Welt-Verlag, ca. 1920. 5 lithographs.

Skizzen aus Litauen, Weissrussland, und Kurland (Sketches from Lithuania, White Russia, and Kurland). Berlin: G. Stilke, Druckerei des Oberbefehlshabers Ost, 1916. 60 lithographs with text by Herbert Eulenberg.

**Skizzen aus Russland* (Sketches of Russia). Druckerei des Oberbefehlshabers Ost, 1916. 50 lithographs in an edition of 25.

Skizzen aus Russland: An der Front vor Riga, 1917 (Sketches of Russia: At the Front at Riga, 1917). Frankfurt am Main: J. Baer, 1918. 50 lithographs in an edition of 25.

**Skizzen aus Russland Ostjuden* (Sketches of Russian and Eastern Jews). Druckerei des Oberbefehlshabers Ost, ca. 1916. 50 lithographs in an edition of 50. Frankfurt: J. Baer, 1918.

*Portfolios marked with an asterisk are in the Judah Magnes Museum collection.

CATALOG

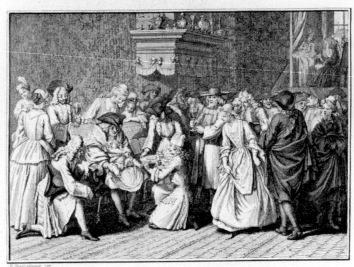

La Circoncision.

BERNARD PICART
1663–1733

Painter, graphic artist, teacher. Born in Paris. To Amsterdam, 1710. Student of his father, Etienne, and of Sebastin Le Clerc. Taught extensively in Amsterdam. Wrote *Figures de modes et théâtrales* (Figures of Fashion and Theater), 1696.

Scènes de la vie juive
(Scenes of Jewish Life), 1884

15 heliogravures by Dujardin of etchings by Ch. Chardon after drawings by Picart, on laid paper; 50.5 × 32.8 cm (19⅞ × 12⅞ in.). Published by Librairie A. Durlacher. Originally published in *Cérémonies et coutumes religieuses de tous les peuples du monde* (Religious Ceremonies and Customs of All the World's People), an 11-volume work published by J. F. Bernard in Amsterdam in 1723 with 600 illustrations by Picart. Issued to subscribers in weekly parts. The first volume contains the section devoted to Jews. Most of the plates engraved by Picart are from his own sketches.

Gift of Rabbi Irving F. Reichert. 76.223

This album presents precise, detailed visual descriptions of early eighteenth-century costumes and synagogue and home interiors. *La Circoncision* is defined in the Bible as follows:

> *[I]t shall be a token of a covenant betwixt me and you. And he that is eight days old shall be circumcised among you, every male throughout your generations.*

Gen. 17:11–12

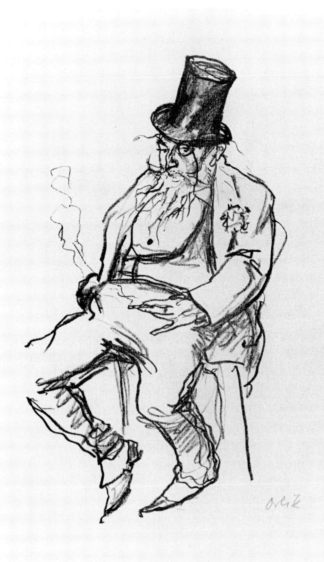

EMIL ORLIK

1870–1932

Painter, draftsman, printmaker. Born in Czechoslovakia. Studied in
Munich. Taught 1903–32 at the Arts and Crafts Academy, Berlin.
Known for his many portraits of prominent contemporaries. This pro-
lific artist executed hundreds of prints and thousands of drawings.
During the Holocaust his works were hidden in a house in the woods
near Prague.

Schauspielerbildnisse aus der Buchse der Pandora

(Pictures of Actors from Pandora's Box), 1919

Illustrations after the 1918 production by Max Reinhardt of Frank
Wedekind's play. 10 lithographs on handmade laid paper;
39.2 × 29.1 cm (15⅜ × 11½ in.); no. 32 of 100. Colophon signed
and dated. Each print signed by the artist. Published by Neue
Kunsthandlung, Berlin.

Gift of Suse Seegall Smetana. 90.26.1.1–10

Orlik's lithographs depict the leading actors in this production of *Pan-
dora's Box*. The cast included Werner Krauss as Schigolch, pictured
here, Gertrud Eysoldt, Emil Jannings, Elsa Wagner, and Margarete
Kupfer.

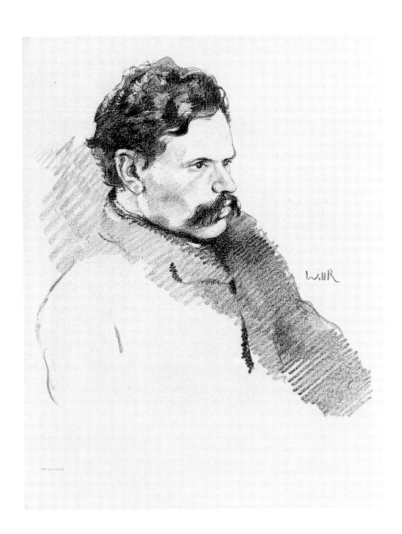

SIR WILLIAM ROTHENSTEIN

1872–1945

Painter, designer, printmaker, watercolorist, writer. Born in England. Studied with Alphonse Legros, Slade School, London; Académie Julian, Paris. Official British war artist in World War I and World War II; knighted in 1931. Professor of civic art, University of Sheffield, 1917–26; Principal, Royal College of Art, 1920–35.

Oxford Characters, 1896

24 lithographs on laid paper; 45 × 30 cm (17¾ × 11⅞ in.); edition limited to 200 copies for England and America. Signed in plate. Printed by Ballantyne, Hanson, and Co., at the Ballantyne Press. Published by John Lane, London; R. H. Russell and Son, New York. Abbey Mills Greenfield watermark. Texts by F. York Powell and others. Each portrait accompanied by biographical sketch. Portfolio is bound. Dedicated to Frederick York Powell Regius, Professor of Modern History at the University of Oxford, Fellow of Oriel, and Senior Student of Christ Church.

Museum purchase by exchange. 87.59.1.1–24

Portraits formed the major part of Rothenstein's art. He is renowned for painting famous people, such as Emile Zola, Henry James, and Auguste Rodin. Professor Margoliouth of Oxford University, represented here, was engaged in art, literature, science, and politics.

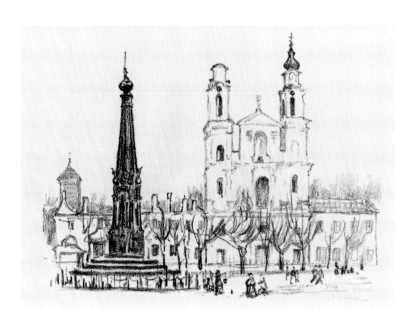

HERMANN STRUCK

1876–1944

Painter, graphic artist, teacher. Born in Germany. Attended Gymnasium and Berlin Academy of Fine Arts. Studied with Jozef Israels in Holland and at the engraving studio of Hans Meyer, Berlin Academy. Taught and influenced many Jewish graphic artists. Elected member of Royal Society of Painters and Etchers, London, 1904. Member Berlin Secession. To Israel, 1923.

Skizzen aus Russland
(Sketches of Russia), 1916

50 lithographs on laid paper; 21 × 28 cm (8¼ × 11 in.) on average; no. 17 of 25. Each print plus title page signed by artist. Produced in the print shop of the German High Command on the eastern front.

Gift of Dr. Susanne Forrest. 84.25.2.1–58

During World War I Struck served in the German army as a translator and as the head of the Department of Jewish Affairs. While at the eastern front he focused his drawings on churches as well as on Jewish subjects.

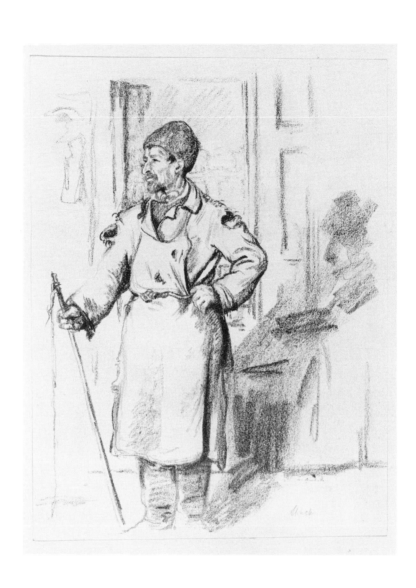

Skizzen aus Russland Ostjuden
(Sketches of Russian and Eastern Jews), ca. 1916

48 lithographs on wove paper; sizes vary from 20.5 × 13.1 cm (8⅛ × 5⅛ in.) to 28.4 × 21.6 cm (11⅛ × 8½ in.); edition of 50. Each print signed by artist. An edition of this portfolio was published by the German High Command while the German army occupied Poland and Lithuania.

Gift of Dr. Susanne Forrest. 84.25.3.1–48

Struck is renowned for portraying the Eastern European shtetl. Much more than sketches, these lithographs are skillfully executed portraits, such as this one of a wagoneer. They provide a rich documentation of a soon-to-vanish way of life.

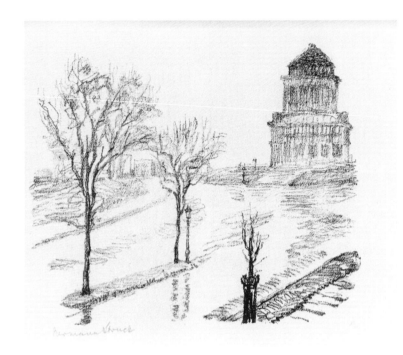

Amerikanische Reisebilder
(American Travel Pictures), 1922

44 lithographs on Japan paper; sizes vary from 14.1 × 20.3 cm (5½ × 8 in.) to 23.6 × 30.5 cm (9¼ × 12 in.); no. 14 of 45. Each print signed by artist. Published by Hans Heinrich Tillgner Verlag, Berlin. Numbers 1–5 were gathered in two separate leather-bound folders; numbers 6–45 in a single leather-bound folder.

Gift of the Women's Guild, The Judah L. Magnes Museum. 84.38.1–44

While visiting the United States and Cuba in 1912 and 1913, Struck recorded his observations in a series of sketches. Grant's Tomb, pictured here, the skyscrapers, and the Statue of Liberty in New York, and the Capitol and White House in Washington, D.C., are among the many buildings and monuments that fascinated and inspired this accomplished artist.

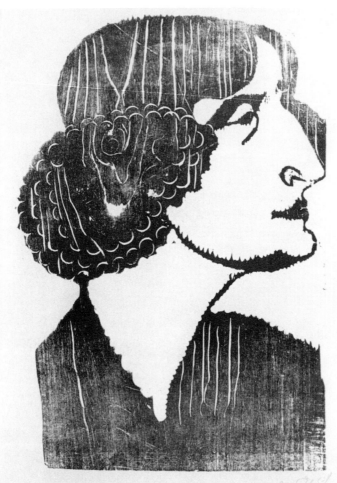

Portrait de M^{lle} Louise Marion.

CHANA ORLOFF

1880–1968

Sculptor, designer, graphic artist. Born in Russia. To Israel, 1905; to Paris, 1910. Studied drawing at School of Decorative Arts, Paris; sculpture at Russian Academy, Montparnasse. Created sculptures for public monuments in Israel. Made portraits of prominent Jewish contemporaries including David Ben-Gurion, Sholem Asch, and Reuven Rubin. Decorated Chevalier of the Legion of Honor by French government in 1925.

Bois gravés de Chana Orloff
(Woodcuts of Chana Orloff), 1919

11 woodcuts on wove paper; 56.5 × 38.2 cm (22¼ × 15 in.); no. 8 of 100. Each print signed by artist. Printed by Frazier-Soye, Paris; d'Alignan, editor.

Gift of Frances and Aaron Greenberg. 87.51.1–11

This album is composed of portraits of French women. *Mlle Louise Marion* is a fine example of Orloff's technique of using wood grain as part of the composition.

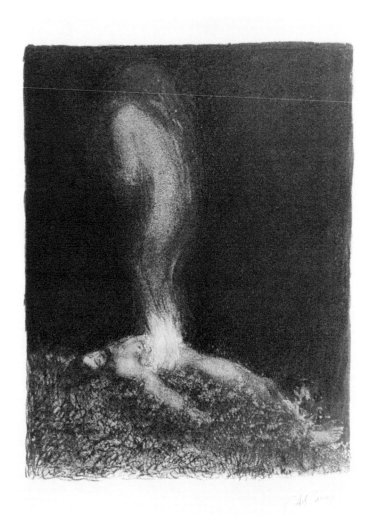

ABEL PANN

1883–1963

Painter, cartoonist, graphic artist, teacher. Born in Latvia. Studied in Odessa, in Vilna, and in Paris under Bouguereau and Toulouse-Lautrec. To Israel, 1913. Taught at Bezalel Academy of Arts and Design. Pann's chief work was illustrations of the Bible.

Genesis, 1925

25 color lithographs on wove paper; 45 × 30.2 cm (17¾ × 11⅞ in.). Each print signed by artist. Published by Jerusalem Palestine Publishing Co.

Gift of Dr. and Mrs. Leon Kolb. 75.130–155

Pann's elegantly composed illustrations of the Bible were the first color lithographs produced in Israel. This print visualizes the following:

And the rib, which the Lord God had taken from the man, made He a woman, and brought her unto the man.

Gen. 2:22

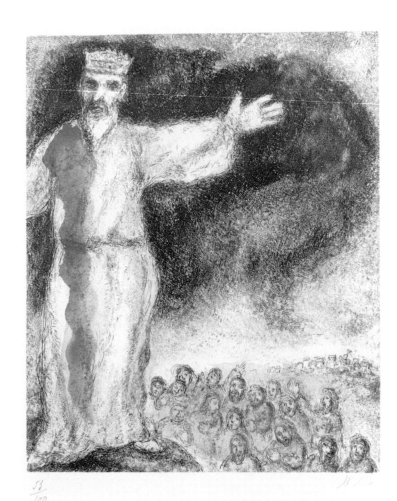

MARC CHAGALL
1887–1985

Painter, graphic artist, watercolorist, ceramicist, designer of theater
sets and costumes, stained-glass windows, and murals. Born in Russia.
Gained prominence as commissar for art, organizing art schools, mu-
seums, exhibitions; director of Vitebst Academy of Art; designer for
Chamber State Jewish Theatre. Settled in Paris, 1923. One of the most
internationally acclaimed Jewish artists of the twentieth century.

Bible, 1956

7 etchings hand-colored from a portfolio of 105 etchings on
Arches paper; 53.9 × 39 cm (21¼ × 15⅜ in.); 5 are no. 53 of 100, 1
is no. 33 of 100, 1 is no. 80 of 100. Each print monogrammed by
artist. Printed by Maurice Patin, published by Teriade, Paris.

Gift of the Baum Family Trust. 88.35.1–7

Commissioned by the Parisian art dealer and publisher Ambroise Vol-
lard to illustrate the Bible, Chagall visited Israel, Syria, and Egypt for
inspiration. By 1939, the year of Vollard's death, Chagall had com-
pleted sixty-six etchings. Persuaded by the publisher Teriade, Chagall
resumed the Bible project in 1952 and completed the series in 1956.
Joshua Stops the Sun refers to the following biblical passage:

Stand still, O sun, at Gibeon
O moon, in the Valley of Aijalon!

Josh. 10:12

ERIC MENDELSOHN
1887–1953

Architect. Born in Germany. Educated in Munich. Designed office buildings, factories, and homes in Berlin. To Britain, 1933. Between 1934 and 1939 designed home and library of Zalman Schocken, Jerusalem; Anglo-Palestine Bank, Jerusalem; Hadassah Hospital, Mount Scopus; Haifa Government Hospital. To the United States, 1945. Designed Maimonides Health Center, San Francisco; many synagogues in the United States. Wrote autobiographical *Letters of an Architect*.

Eric Mendelsohn, 1955

32 lithographs on wove paper; 38.1 × 27.9 cm (15 × 11 in.); no. 47 of 500. Each print titled and dated, some signed in plate. Published by Louise Mendelsohn, United States. Numbers 1–50 are wrapped in raw silk.

Gift of Victor Ries. 75.276

This portfolio, covering a full range of Mendelsohn's designs, includes drawings of projects never built, such as *World University* illustrated here.

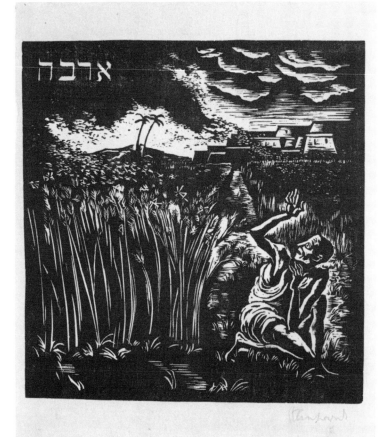

JAKOB STEINHARDT
1887–1968

Painter, graphic artist, teacher, theater set and costume designer. Born in Germany. Studied with painter Lovis Corinth and etcher Hermann Struck, Berlin; with Henri Laurens, Théophile Steinlen, and Henri Matisse, Paris. With Ludwig Meidner and Richard Janthur founded expressionist group *Die Pathetiker*, 1912. To Israel, 1933. Headed graphic department, Bezalel Academy of Arts and Design, 1949; director, Bezalel Academy, 1953–57.

The Ten Plagues, 1920

10 black-and-white woodcuts on laid paper; 30.8 × 26 cm (12⅛ × 10¼ in.); edition of 60. Each print signed by artist. Published by Gurlitt.

Gift of Suse Seegall Smetana. 90.26.2.1–10

Locusts depicts one of the ten plagues that God sent to force the Egyptians to release the Israelites. The recitation of the plagues is an essential part of the Passover Haggadah.

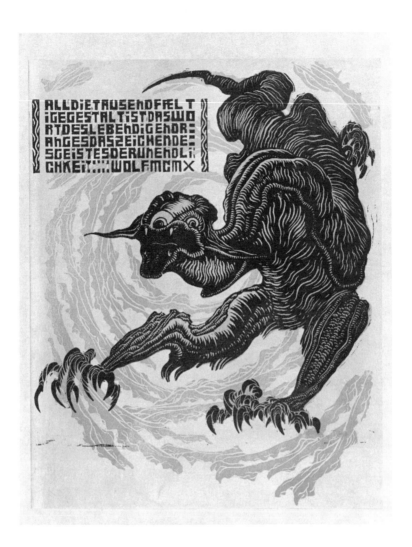

GUSTAV WOLF
1887–1947

Printmaker, muralist, sculptor, teacher. Born in Germany. Professor of graphic arts at the Academy of Fine Arts, Karlsruhe, until Nazis came to power. To the United States, 1938. Taught at Smith College and Northfield School for Girls, Massachusetts.

Gustav Wolf: Zehn Holzschnitte
(Ten Woodcuts), 1910

10 woodcuts on wove paper; 38.1 × 30.7 cm (15 × 12⅛ in.); no. 52 of 120. Signed in block *W*. Title page signed and numbered. Printed by M. Gillardon, Karlsruhe im Bad; published by Verlag Der Quelle, Karlsruhe and Leipzig.

Gift of Mrs. H. Fuchs. 72.22

Wolf expresses his idea of spirituality in this print as follows: "The multifaceted form is the word of the living driving force, the testimony to the spirit of infinity."

Wolf, 1910

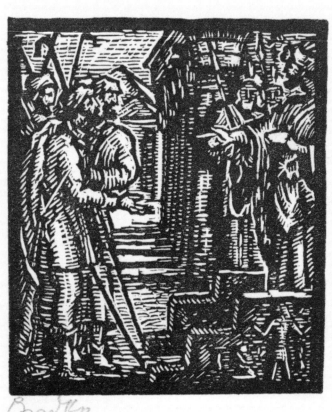

JOSEPH BUDKO

1888–1941

Mainly graphic artist; made etchings, woodcuts, lithographs. Born in Poland. Studied at Academy of Fine Arts, Vilna, and with Hermann Struck in Berlin, 1910. To Israel, 1933. Taught at Bezalel Academy of Arts and Design; director, 1935–40.

Genesis, not dated

11 woodcuts on Japan paper; 6 × 4.7 cm (2⅜ × 1⅞ in.). Printed by Fritz Voigt, Berlin. Published by Welt-Verlag, Berlin. Number unknown of 100 copies of 12 prints numbered I–XX and 21–100. I–XX enclosed in vellum cover, 21–100 in ordinary hardcover with leather-covered spine.

Gift of Mr. and Mrs. Alfred Fromm. 70.33.1–11

This series of miniature woodcuts reflects Budko's personal style rooted in the craft of metal engraving. *Joseph and His Brothers* depicts the following biblical passage:

And they said unto him: "Nay my lord, but to buy food are thy servants come."

Gen. 42:10

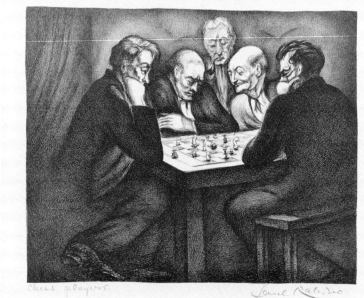

Chess players. Saul Raskin

SAUL RABINO

1892–1969

Painter, graphic artist, muralist. Born in Russia. To the United States, 1922. Studied at Imperial Art School, Russia; School of Decorative Arts, Paris, 1913. Murals at Los Angeles Jewish Home for the Aged.

Original Lithographs by Saul Rabino

11 lithographs on laid paper; 51.5 × 33.5 cm (20¼ × 13¼ in.). Each print signed by artist. Published by Saul Rabino Art Committee, Los Angeles. Introduction by Monte Salvin, M.D., chairman, Saul Rabino Art Committee; preface by Arthur Millier, art critic, *Los Angeles Times*, 1939.

Gift of Mrs. Michael Gordon. 71.38

Rabino's album represents various themes. Included are portraits of the prophets Micah, Malachi, and Jeremiah, and scenes of people engaged in leisure activities, such as is seen in *Chess Players*.

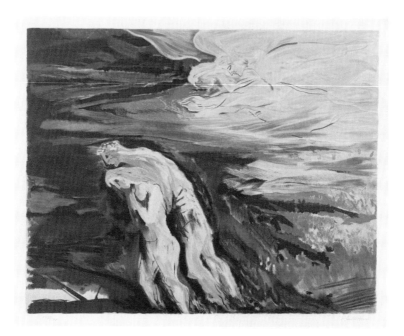

ABRAHAM RATTNER

1893–1978

Painter, printmaker, tapestry designer, teacher. Born in the United States. Studied at George Washington University and Corcoran School of Art, Washington, D.C.; Pennsylvania Academy of the Fine Arts, Philadelphia, 1916–17; Académie Julian, Paris; Académie des Beaux-Arts, Paris; Académie Ranson, Paris; Académie de la Grande Chaumière, Paris, 1920. Taught at New School for Social Research, New York, 1947–55; Yale University, 1949; Brooklyn Museum School, 1950–51; American Academy, Rome, 1951; University of Illinois, 1952–54; Art Students League, New York, 1954; Pennsylvania Academy of the Fine Arts, 1954; Sag Harbor Summer Art Center, 1956; Michigan State University, 1956–58.

In the Beginning . . . , 1972

12 color lithographs on Arches paper; 65×55 cm ($25\,^5/_8 \times 21\,^5/_8$ in.); no. 178 of 200. Each print signed by artist. Lithography by Mourlot, typography by Fequet et Baudier, Paris. Published by William Haber. Preface by Henry Miller, introduction by William Haber.

Gift of Dr. and Mrs. Philip Bader. 86.36.1–12

Rattner's radiant, painterly color lithographs illustrate specific biblical passages. *Paradise Lost* shows the following:

> *Behold, the man has become like one of us, knowing good and evil; and now, lest he put forth his hand and take also of the tree of life, and eat and live forever.*

Gen. 3:22

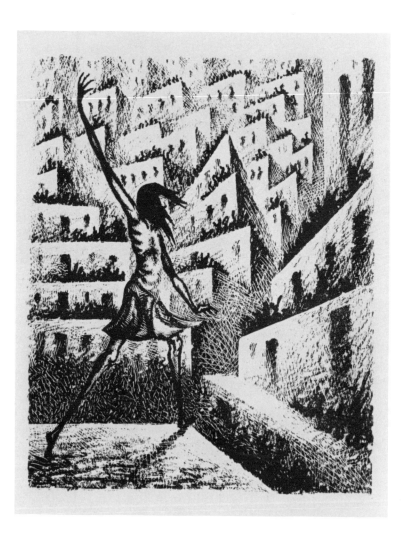

URIEL BIRNBAUM

1894–1956

Graphic artist, poet. Born in Vienna, Austria. Son of philosopher Nathan Birnbaum. Severely wounded in 1917 when fighting in Austrian army. Wrote volume of sonnets, *In Gottes Krieg*, 1921. Published several portfolios and volumes of lithographs and paintings, including *Der Kaiser und der Architekt* and *Moses*, both 1924. To Amsterdam after annexation of Austria by Germany.

Das Buch Jonah
(The Book of Jonah), 1921

17 black-and-white lithographs on wove paper; 43.5 × 30.5 cm (17 1/8 × 12 in.); no. 42 of 300. Title page and 4 initial letters with illustrations by Birnbaum; 6 pages of text written by Julius Zimpel. Title page signed in stone; colophon signed by artist and Zimpel. Printed by Rikola Printing Press A.G. and A. Berger, Vienna.

Museum purchase with funds provided by friends of Mr. and Mrs. Robert Fischer in honor of their 50th wedding anniversary and by the Art and Culture Council, Judah Magnes Museum. 90.37

Birnbaum's expressionistic lithograph depicts the prophet Jonah, who, on God's command, preached to the Ninevites to repent their evil ways.

Jon. 3:1–10

WELTUNTERGANG

Zwölf Original-Lithographieen
und lithographiertes Titelblatt
von
Ariel Birnbaum
Mit einem Einleitungssonett des Künstlers

Verlegt bei Carl Konegen
WIEN
19 21

Weltuntergang
(The Destruction of the World), 1921

12 lithographs and lithographic title page on Japan document paper; 48.4×35 cm (19×13¾ in.); no. 134 of 150. Includes table of contents. Page numbers 1, 2, 4, 6, 12 plus title page and sonnet signed by artist. Printed at the "Secession" Graphic Art Academy, previously Albert Berger, Vienna, under the supervision of the artist. Commissioned and published by Carl Konegen, Vienna. Introductory sonnet by the artist. Edited by Carl Konegen.

Museum purchase, with funds provided by Acquisitions Committee. 90.16.1–12

The meaning of Birnbaum's scenes can be clarified by his introductory sonnet. The first stanza is translated as follows:

Even if this world would become more beautiful
And ultimately would only know happiness, no longer suffering
With all the happiness, the world still remains the world
And remains the illusion of a span of time.

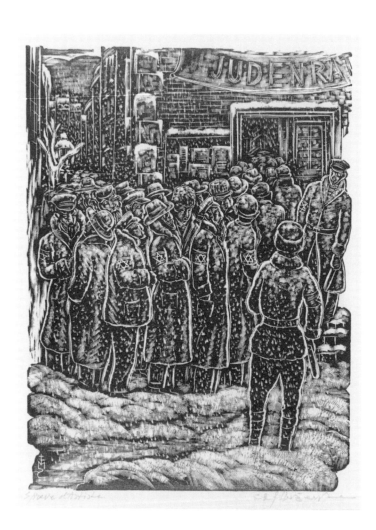

Steve Artiste

STEFAN MROZEWSKI

1894–1975

Painter, printmaker, book illustrator. Born in Poland. Studied at Academy of Fine Arts, Warsaw. To Paris, 1925; to Amsterdam, 1932. Illustrated 25 books including Dante's *Divine Comedy*. Back to Poland, 1939; joined Polish Resistance Forces. To California, early 1950s.

Ghetto of Warsaw, 1946

16 woodcuts on laid paper; 33×26.8 cm ($13 \times 10\frac{5}{8}$ in.). Artist's proof. Each print signed by artist. Introduction by Henry Kanarek. Reproductions of these prints were published in portfolio form by the Magnes Museum in 1966.

Museum purchase. 76.111

Assignments in the underground of the Polish Resistance Forces brought Mrozewski, a non-Jew, to the Warsaw Ghetto in 1939. There he began a series of sketches based on the atrocities he witnessed, such as *Forced Labor*. Completing the set in Paris in 1946, Mrozewski dedicated it to those "who suffered and died in the modern inferno."

MORDECAI ARDON
b. 1896

Painter, graphic artist, designer of wall tapestries, stained-glass windows, teacher. Born in Poland; lives in Israel and Paris. Studied at the Bauhaus in Weimar with Lyonel Feininger, Wassily Kandinsky, and Paul Klee, 1920–25; with Max Doerner at the State Art Academy, Munich, 1926; at Johannes Itten Art School, Berlin, 1929. To Israel, 1933. Taught drawing at Bezalel Academy of Arts and Design. Director of Bezalel, 1940–52; lecturer at Hebrew University, 1949–58. Artistic advisor to Israeli Ministry of Education and Culture, 1952. Honorary doctorate of philosophy, Hebrew University, 1974.

Jerusalem

A portfolio of works by eight artists:
Mordecai Ardon; Shmuel Bak (b. 1933, Lithuania; lives in Israel); Johnny Friedlaender (b. 1912, Pless, in upper Silesia; lives in Paris); Victor Vasarely (b. 1908, Hungary; lives in France); Marcel Janko (b. 1895, Romania; d. 1984 in Israel); Yossl Bergner (b. 1920, Austria; lives in Israel); Avigdor Steimatsky (b. 1908, Russia; lives in Israel); Yehezkel Streichman (b. 1906, Lithuania; lives in Israel).

8 prints: 2 color lithographs, 1 color etching, 5 color screenprints, on Arches paper; 50 × 65 cm (19⅝ × 25⅝ in.); no. 92 of 135. All prints signed but not dated. Lithographs printed by Atelier Mourlot, Paris; etching printed by Atelier Georges Leblanc, Paris; screenprints printed by Silium, Paris; Mambush, Ein-Hod; and Harel, Ganot. Commissioned and published by Arta Gallery, Jerusalem. Foreword by Teddy Kollek, mayor of Jerusalem. Biographies of each artist and biblical quotes in English and Hebrew.

Gift of Florence and Leo Helzel. 84.33.1.1–8

Each of the eight artists represented in this portfolio conceptualized the Eternal City in his own distinctive style. Ardon's lithograph *Rejoice ye with Jerusalem* recalls the following biblical passage:

Rejoice ye with Jerusalem and be glad with her, all ye that love her: rejoice for joy with her, all ye that mourn her.

Isa. 66:10

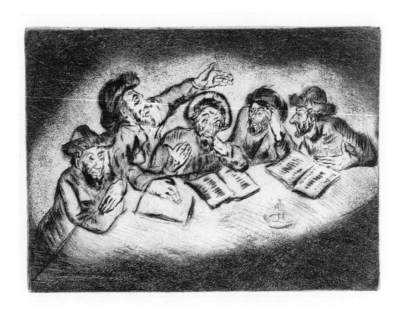

DAVID BEKKER
1897–1956

Painter, printmaker, sculptor, medal designer. Born in Vilna, Russia. Studied at Antokolsky Art School, Vilna; Bezalel Academy of Arts and Design, Jerusalem; Denver Academy of Art, Colorado. Lived in Chicago. Published *Myths and Moods*, a collection of linocuts, in 1932.

Two Worlds, 1936

10 drypoints on wove paper; sizes vary from 24 × 19.8 cm (9½ × 7¾ in.) to 27.7 × 36 cm (10⅞ × 14⅛ in.). Published by M. Ceshinsky, Chicago. Preface by C. J. Bulliet, art critic of the *Chicago Daily News*. Biography of artist and explanatory notes in English and Yiddish. Biography by Lawrence Lipton.

Museum purchase. 88.16.1–10

Bekker's album focuses on age-old traditions and folklore of the ghetto. In *A Talmudical Disputation* participants discuss the Talmud, a written compilation of oral teachings about Jewish law and custom. Each speaker excitedly puts forth his view of the question.

BEN-ZION
1897–1987

Painter, sculptor, poet, teacher. Born in Russia. Son of a cantor. Studied at Art Academy, Vienna. Prepared for rabbinical career. Studied Hebrew literature, 1917–31. Wrote poetry in Hebrew. To the United States, early 1930s. Worked on W.P.A. commissions. Taught painting at Cooper Union, New York, 1943–50. Retrospectives at Jewish Museum, New York, 1959 and Haifa Museum, 1975. Exhibition, *A Tradition of Independence*, Magnes Museum, February 16–May 11, 1986.

Biblical Themes, 1950

18 etchings on Grand Vélin d'Arches, pur chiffon; 56.5 × 44.9 cm (22¼ × 17⅝ in.); no. 49 of 65. Each print signed by artist. Printed by Roger Lacourière, Paris; trial proofs printed by Karl Schrag, New York. Published by Curt Valentin, New York.

Museum purchase. 90.19.1.1–18

Interpreting the Bible, which reflects his early education in a Ukrainian yeshiva, has been a major part of Ben-Zion's art. These eighteen etchings narrate passages from the Pentateuch, the first five books of the Bible. This illustration refers to the following:

She took of the fruit thereof and did eat and gave also unto her husband.
Gen. 3:6

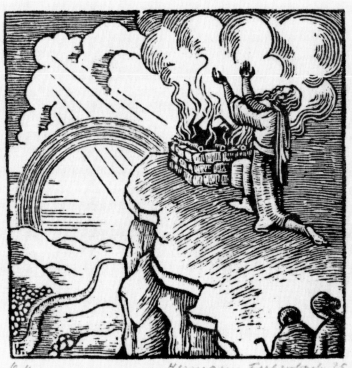

O. 4. Hermann Feibenbach 25.

HERMANN FECHENBACH

b. 1897

Painter, graphic artist. Born in Germany. Studied at art academies in Stuttgart, Munich, Florence, and Vienna, 1919–26. To England, 1939; settled in Oxford, 1941. Especially gifted in wood engraving. Exhibition of wood engravings and linocuts held at Blond Fine Art, London, 1985.

Die Bibel: Das erste Buch Moses
(The Bible: The First Book of Moses), ca. 1920s

135 woodcuts; sizes vary from 3.5×3.5 cm (1⅜×1⅜ in.) to 6.5×6.5 cm (2½×2½ in.). Edition of 200. Each print signed by artist.

Gift of the artist. 77.34

Fechenbach chose his favored medium of the woodblock for these miniature prints. *God's Covenant* describes the following biblical scene:

Noah built an altar for Yahweh, and choosing from all the clean animals and all the clean birds he offered burnt offerings on the altar.

Gen. 8:20

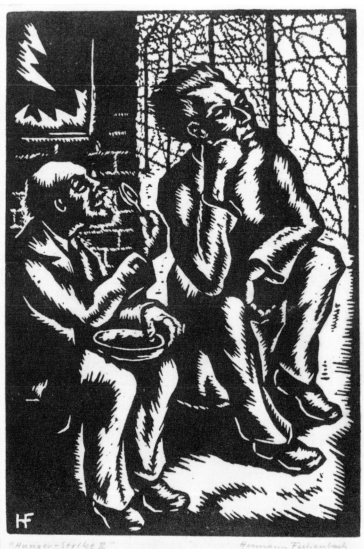

"Hunger-Strike II" Hermann Fetkenbach

My Impressions as Refugee, 1941–46

21 linocuts on wove paper, 20 in black and white, one in color;
21 × 14.2 cm (8¼ × 5⅝ in.). Each print signed and titled by artist.

Gift of the artist. 76.178

Fechenbach's autobiographical linocuts, the "Isle of Man" series, con-
tain powerful imagery of camp life and Nazi leaders. *Hunger Strike II*
expresses the injustice of the artist's internment.

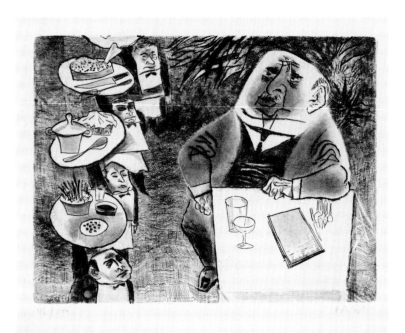

WILLIAM GROPPER

1897–1977

Painter, graphic artist, cartoonist, teacher, designer of stained-glass windows. Born in the United States. Studied at Ferrar School, New York, 1912–13; with Robert Henri, George Bellows; at National Academy of Design; New York School of Fine and Applied Art. Staff artist, *New York Tribune*, 1919–21; *New York World*, 1925–27.

Gropper: Twelve Etchings, 1965

12 etchings on Rives BFK paper; 47×56.2 cm ($18\,^1/_2 \times 22\,^1/_8$ in.); no. 48 of 100. Each print signed by artist. Printed by Emiliano Sorini, New York; chopmark: ES. Edited by Associated American Artists, New York. Foreword by Alan Fern.

Museum purchase. 90.19.2.1–12

These are the first etchings created by Gropper, an accomplished draftsman who commented on social and political issues in his art. *The Gourmet* highlights Gropper's mastery of caricature.

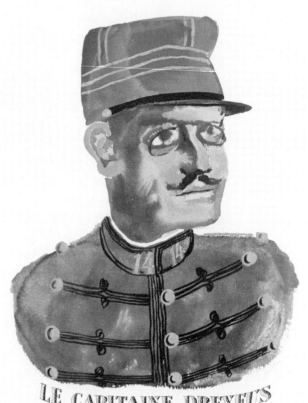

LE CAPITAINE DREYFUS

BEN SHAHN

1898–1969

Painter, graphic artist, cartoonist, designer of frescoes, murals, posters, theater sets, books. Born in Lithuania. To the United States, 1906. Studied at New York University; City College of New York; National Academy of Design, New York; Art Students League, New York.

The Dreyfus Affair, 1984

8 pochoir prints on Arches paper; 39 × 30 cm (15⅜ × 11¾ in.); no. 123 of 450. Signed in plate. Printed by Young and Klein, Inc.; published by Crossroads Books, Ohio. Essays by Bernarda Bryson Shahn, Egal Feldman, and Charles Westheimer. Design and typography of this book, box, and folders by Noel Martin. The typeface is Basilia Haas, produced in Switzerland and photocomposed on a Linotron 202 by Cobb Typesetting Company. Offset lithography by Young & Klein, Inc. The decorative paper is Curtis Flannel; the text pages are Curtis Colophon. The binding by the Cincinnati Bindery.

Gift of Stephen and Dolores Taller in memory of Gladys and Alex Taller. 86.33

Shahn is noted for art that deals with social issues, as well as with Jewish subjects. In 1930 he painted portraits of the main characters involved in the Dreyfus Affair. In 1969 he executed the pochoir prints intended for the publication of a book by Trianon Press. Both Shahn and the owner of the press, Arnold Fawcus, died before completion. This publication is the realization of their plan.

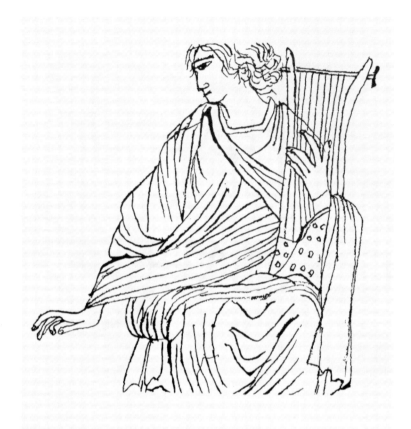

Halleluja, 1970–71

24 lithographs on wove paper; 41.5 × 44.4 cm (16⅜ × 17½ in.); no. 104 of 240. Signed in plate on last page. Titles in English and Hebrew. Lithographs reproduced by Mourlot Graphics, Ltd., New York. Typography by The Spiral Press, New York. Published by Kennedy Graphics, New York. Binding and cases by Moroquain Bindery, New York.

Gift of Stephen and Dolores Taller in memory of William and Sarah Shedroff.

87.53a–b

These lithographs, drawn just before Shahn died, represent his last completed work and illustrate Psalm 150. This image refers to the line: "Praise Him with harp and lyre."

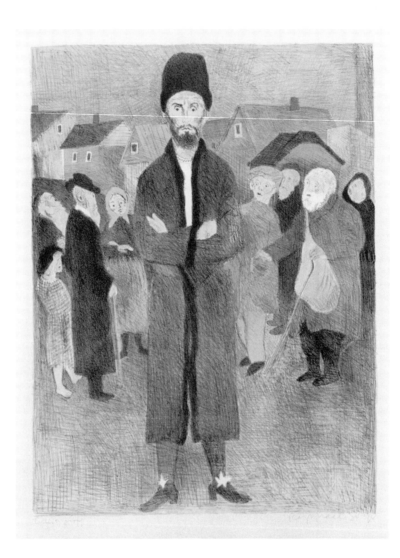

RAPHAEL SOYER

1899–1987

Painter, printmaker, teacher. Born in Russia. To the United States, 1912. Studied in New York at Cooper Union, National Academy of Design, and Art Students League with Guy Pène du Bois. Awarded many art prizes and medals. Exhibited internationally. Work represented in major museum collections. Illustrated 3 books by the Nobel Prize–winning author Isaac Bashevis Singer.

The Mirror and *The Gentleman from Cracow*, 1970

12 color lithographs including one portrait of Isaac Bashevis Singer on Arches paper; 65.9 × 48.4 cm (26 × 19 in.); artist's proof. Each print signed by artist; title page signed by Isaac Bashevis Singer. Printed by Bank Street Atelier, New York; chopmark: BSA. Text printed by Fequet et Baudier, Paris. Typography and design by Aline Elmayan, Paris. Published by Touchstone Publishers, New York. "The Gentleman from Cracow" and "The Mirror" are reprinted from the book *Gimpel the Fool and Other Stories* by Isaac Bashevis Singer by arrangement with the publisher, Farrar, Straus and Giroux, Inc., copyright © 1957 by Isaac Bashevis Singer. The text for "The Gentleman from Cracow" is translated by Martha Glicklich and Elaine Gotlieb; "The Mirror" is translated by Norbert Guterman.

Gift of Herbert and Nancy Bernhard. 84.64.1.1–12

These twelve prints illustrate two popular stories by Singer. He distinguishes the doctor from Cracow, pictured here, as follows: "It was a Jew . . . a young tall man . . . pale with a round beard and fiery dark eyes. . . ."

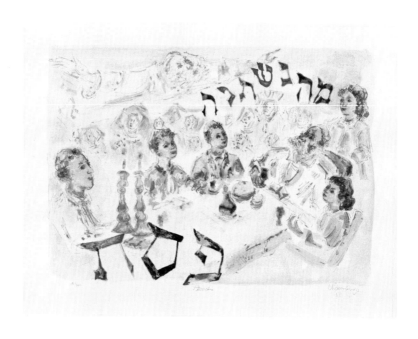

CHAIM GROSS

b. 1904

Sculptor, painter, watercolorist, graphic artist, teacher. Born in Austria. To the United States, 1921. Studied at Kunstgewerbe Schule, Vienna; Educational Alliance, New York; Beaux-Arts Institute of Design, New York, with Elie Nadelman; Art Students League, New York, with Robert Laurent. Received many commissions, awards. Work represented in major museums.

The Jewish Holidays, 1968

11 color lithographs on Rives paper; 48.1 × 62.9 cm (18⅞ × 24¾ in.); no. 191 of 200. Each lithograph signed, numbered, and titled by artist. This suite of 10 original lithographs, plus title page, of the Jewish holidays was created by Gross in Paris in 1968 for Associated American Artists. He was assisted by the master lithographer Marcel Salinas. The lithographs were printed on the presses of Georges Trotignon and Lucien Détruit. The typography for the text was composed by hand and printed on the presses of Pierre Jean Mathan on Vélin pur chiffon des Papeteries de Lana. The stones and plates have been erased.

Gift of Renee and Chaim Gross in honor of Tom Freudenheim. 90.3.2.1–11

Gross visually describes the most important Jewish holidays. During the Pesach service the family is transported back three thousand years and experiences the bitterness and exaltation of their forebears. The unity is expressed in the words: "This we do, because of what God did for me when I came forth out of Egypt."

The Song of Songs, 1980

9 color lithographs on Arches paper, mold-made in France by Ar-
jomari Prioux; 53.3 × 43.5 cm (21 × 17 ⅛ in.); edition of 4 artist's
proofs. Each print signed by artist. Lithographs were pulled from
plates hand drawn by Gross and printed in Paris under his super-
vision. The original watercolors were commissioned by The Lim-
ited Editions Club of New York for its edition of *The Song of Songs*,
published in 1980. Published by The Print Club, New York.

Gift of Renee and Chaim Gross in honor of Tom Freudenheim. 90.3.1.1–9

Excerpts in Hebrew from the lyrical verses of King Solomon are inte-
grated into the design of this color lithograph:

Behold, you are fair, my love,
Behold, you are fair with your eyes as doves
Behind your veil.
Your hair is like a flock of goats,
Trailing down Mount Gilead.

Song of Sol. 4:1

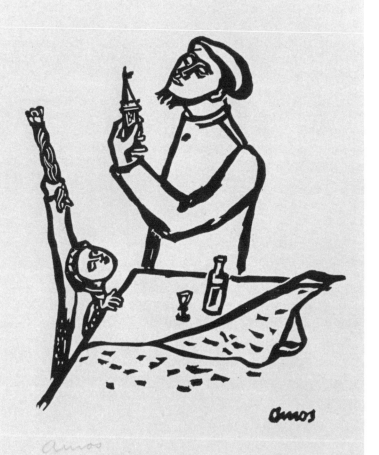

IMRE AMOS

1908–1945

Painter, printmaker. Born in Hungary. Attended School of Fine Arts, Budapest. Made study trip to Paris in 1937 where he met Chagall and Picasso. From 1940 he was forced to labor in Hungarian work camps. In 1944 he was deported to Germany where he died in a concentration camp.

Amos Imre 14 eredeti metszete
(Fourteen Linocuts), 1940

14 linocuts on wove paper; 34.5 × 28 cm (13⅝ × 11 in.); no. 100 of 150. Each print signed by artist. Printed by Hungaria R. T., Budapest, Lehel Bano, director. Published by Imre Amos. Introduction by Geza Ribary, president of the National Hungarian Jewish Assistance Organization. Commentaries by Dr. Ernst Naményi.

Gift of Ellen Miller in honor of Leslie Kessler's birthday (1–12); Gift of Ann Gabor Arancio in honor of Leslie Kessler's birthday (13–14). 87.30.1–14

Amos's portfolio features Jewish festivals, ceremonies, and customs. Here he illustrates the Havdalah service, which concludes the Sabbath. Prayers recited over a spice box, braided candle, and glass of wine separate the Sabbath from the rest of the week.

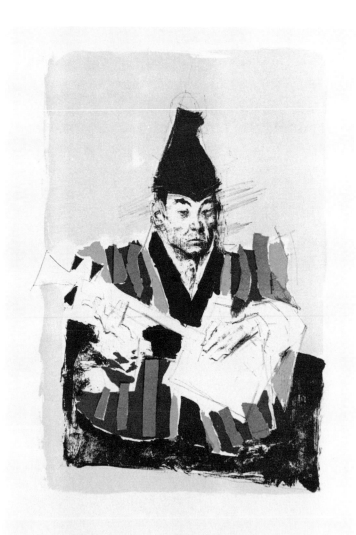

JACK LEVINE

b. 1915

Painter, graphic artist. Born in the United States. Studied with Denman W. Ross, Harold Zimmerman. Taught at American Art School, New York; Pennsylvania Academy of the Fine Arts, Philadelphia; Skowhegan School of Painting and Sculpture, Maine; Cleveland Museum of Art; Art Institute of Chicago; University of Illinois.

Facing East, 1970

54 watercolors, gouaches, and drawings from the sketchbook by Jack Levine printed by phototype and pochoir processes on Ingres paper; from 2 to 40 colors hand-brushed on each. For this edition, 4 lithographs were printed on Rives BFK paper by the Bank Street Atelier, New York. 48 × 31.1 cm (18⅞ × 12¼ in.); no. 1038 of 2500. Portfolio signed by Levine and James A. Michener. Typography and original woodcuts printed by Fequet et Baudier, Paris. Sketchbook printed by Daniel Jacomet, Paris. Published by Maecenas Press, Random House, New York. Text by James A. Michener. Portfolios executed by Adine, Paris. Design and supervision by Aline Elmayan, Paris.

Gift of Florence and Leo Helzel. 89.58.1–58

This portfolio is a graphic account of people and places Levine observed while visiting Japan, Hong Kong, Thailand, and Cambodia. *Samisen Player* captures the spirit and historic tradition of Japanese prints.

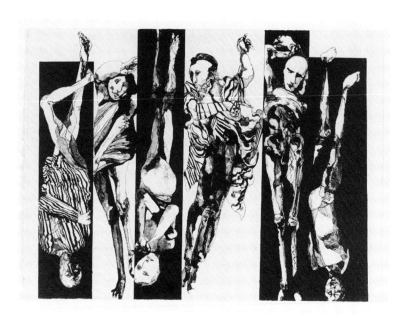

JACOB LANDAU
b. 1917

Graphic artist, printmaker, watercolorist, professor of art, lecturer. Born in Philadelphia. Studied at Philadelphia Museum School; New School for Social Research, New York; Académie de la Grande Chaumière, Paris. Taught at the School of Visual Arts, New York; Philadelphia College of Art; Pratt Institute, New York.

Holocaust: Six Lithographs by Jacob Landau, 1968

6 lithographs on Arches paper; 38 × 51.5 cm (15 × 20¼ in.); no. 16 of 40. Each print signed and titled by artist. These images were originally commissioned by the Union of America Hebrew Congregations for reproduction in *Out of the Whirlwind: A Reader of Holocaust Literature*, edited by Albert H. Friedlander. Drawn on zinc, they were subsequently published as a suite by Associated American Artists, New York. 50 proofs from each plate were pulled on Arches paper. 10 were retained by the artist. Typography by Douglas Wink; binding by Spink and Gaborc. Preface excerpted from *Out of the Whirlwind*.

Gift of Stephen and Dolores Taller in memory of William and Sarah Shedroff.

89.66.1–6

Landau developed the somber images in *Holocaust* from his encounters with concentration camp survivors. Dramatic black washes add forceful impact to his message of horror and outrage.

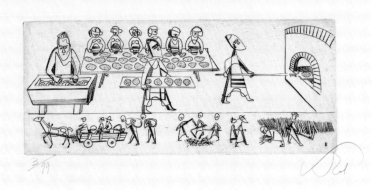

ABRAM KROL

b. 1919

Painter, graphic artist, sculptor, designer of tiled panels, large-scale enamels. Born in Poland. To Paris, 1939. Studied at School of Fine Arts, Avignon; Caen University. Designs and publishes his books.

Haggadah, 1966

24 copper engravings on Rives paper; 24.7 × 32.5 cm (9¾ × 12¾ in.); no. 3 of 99. Each print signed by artist. Printed by Moret, Paris. Published by the artist.

Gift of Dr. and Mrs. Bernard Horn. 79.69.3.1–24

Krol stated that in his *Haggadah* he "wanted to show by starting with creation and by the successive stages of our history how we had arrived at the deliverance from Egypt." *Cuisson des matzot* depicts the baking of the unleavened bread that is eaten during the eight-day celebration of Passover to symbolize the hasty exodus from Egypt.

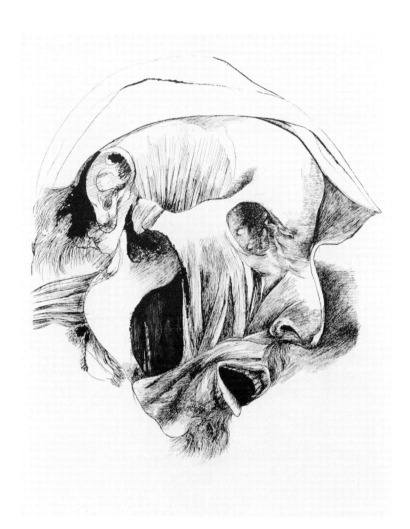

LEONARD BASKIN

b. 1922

Sculptor, painter, printmaker, watercolorist, author, teacher, book designer, publisher. Born in the United States. Studied at New York University; Yale University; New School for Social Research, New York; Académie de la Grande Chaumière, Paris; Academy of Fine Arts, Florence, Italy; and privately with Maurice Glickman. Owns and operates the Gehenna Press.

Ars Anatomica
(A Medical Fantasia), 1972

13 photo-offset lithographs on specially made paper bearing the private watermark of Medicina Rara and manufactured by E. Towgood and Sons, Sawston, Cambridgeshire, England; 56.5 × 39 cm (22¼ × 15⅜ in.); no. 1087 of 2500. Each print signed and dated in plate; colophon signed by artist. Printed by The Curwen Press Ltd., London, England, for the members of Editions Medicina Rara Ltd. The plates were made from 13 original drawings, commissioned by Medicina Rara. Published by Medicina Rara, New York. This is one of 2500 single suites in boxed portfolios covered in a Bugra laid paper, which are numbered in arabic numerals 1–2500. The portfolio boxes were created at the bindery of Richard Mayer, Stuttgart, Germany. Introduction by John E. Marqusee.

Gift of Sandi Sofris. 83.85.2.1–13

Historical anatomical illustrations have profoundly influenced Baskin's art. This drawing, displaying stripped-away layers of flesh, results in a powerful but vulnerable image of man.

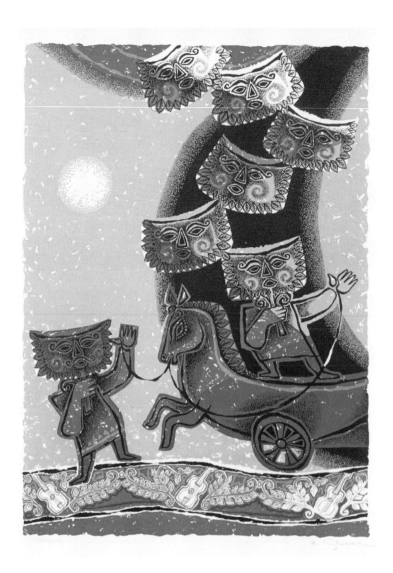

PINCHAS SHAAR

b. 1923

Painter, printmaker. Born in Poland. Studied art in Munich, and at the School of Fine Arts and the Académie de la Grande Chaumière, Paris. To Israel, 1956.

Jewish Holidays, 1977

10 color screenprints on Rives paper; 76.2 × 55.9 cm (30 × 22 in.); no. 36 of 125. Each print signed by artist. Printed by Tzipelee, New York; published by B. L. D. Limited. Preface by Raymond Cogniat, art editor and critic of *Le Figaro*, Paris.

Gift of M. Magidson and Associates. 79.33.1–14

Each of Shaar's brilliantly colored prints is an autonomous work, describing in a naive, playful manner the annual Jewish holidays. *Purim* celebrates Queen Esther's triumph in saving the Jews from Haman's plans of extermination.

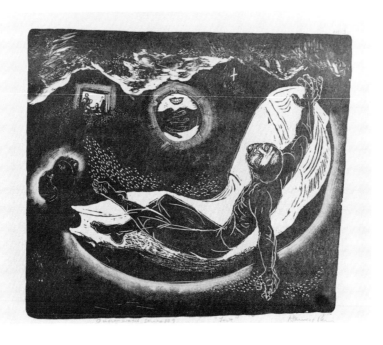

HAROLD PARIS

1925–1979

Sculptor, printmaker, author. Born in the United States. Studied at Atelier 17, New York, 1949; Creative Lithographic Workshop, New York, 1951–52; Academy of Fine Arts, Munich, 1955–56. Taught at University of California, Berkeley, 1960–79.

Buchenwald Series, 1950

9 woodcuts on Japan rice paper; sizes vary from 51.3 × 55.9 cm (20¼ × 22 in.) to 34.7 × 25.6 cm (13¼ × 10 in.); edition of 30. Each print titled and signed by artist. Paris most likely printed and published this set himself while living in New York. Probably 21 prints in set.

Gift of the artist. 77.4.1–9

Paris based his first significant work on the evils of the Nazi concentration camp. *In Death Together* reveals influences of expressionism, which are combined with the artist's fine draftsmanship.

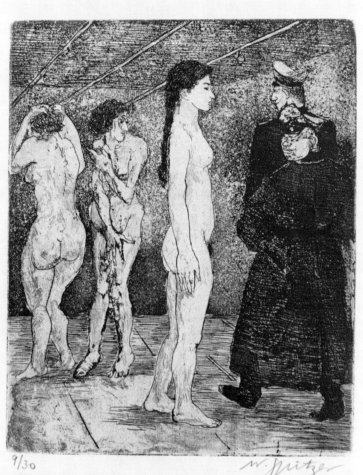

9/30 W. Spitzer

WALTER SPITZER
b. 1927

Painter, graphic artist, sculptor, book illustrator. Born in Poland; to France. Studied at the School of Fine Arts, Paris, entered 1945. Illustrated books by André Malraux, Joseph Kessel, Henry de Montherlant, and Jean-Paul Sartre.

Memory of the Shoah, 1955

9 etchings on Rives BFK paper; sizes vary from 11.8 × 18 cm (4⅝ × 7 in.) to 24.9 × 24.3 cm (9¾ × 9½ in.); no. 9 of 30. Each print signed by artist. Printed gratis by J. J. J. Rigal, Paris. Published by the artist.

Gift of the artist. 90.25.1.1–9

The awesome bestiality of man is recorded in Spitzer's autobiographical scenes of Auschwitz.

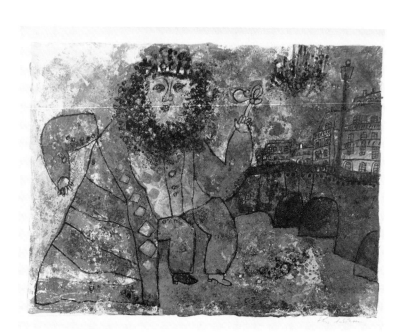

THEO TOBIASSE

b. 1927

Painter, graphic artist, sculptor. Born in Israel. To Lithuania, 1929; to Paris, 1931. Studied theater design at the Comédie Française, 1946–47; School of Decorative Arts, Paris; Center for Dramatic Art, Paris. Lives in New York and St.-Paul-de-Vence.

The Song of Songs of King Solomon, 1976

12 color lithographs on white Japan paper; 55.5 × 75.7 cm (21⅞ × 29¾ in.); H.C. LXV. Each print signed and accompanied by biblical text, in English and Hebrew. Printed by Mourlot, Paris; published by Amiel, Paris.

Gift of Doctors Madlyn W. and H. Thomas Stein. 82.65.1–12

This is one of fifteen portfolios by Tobiasse published between 1975 and 1984. Exaggerated forms parallel the extravagant poetic expressions contained in the *Songs.*

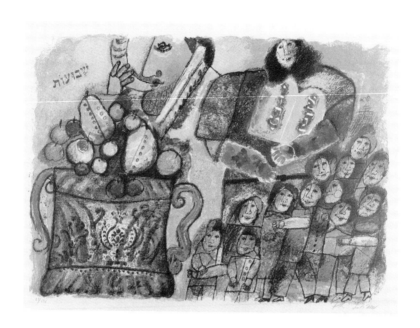

Shavuot, 1984

4 color lithographs, each combining over 20 hand-printed lithograph colors with carborundum etching and embossing on Arches paper; 54.6 × 76.8 cm (21½ × 30¼ in.); no. 87 of 125. Each print signed. Published by Nahan, New Orleans; chopmark: Nahan. Title page contains colophon and text by Rabbi Marvin Hier, Simon Wiesenfeld Center.

Gift of Mr. and Mrs. Kenneth Nahan. 90.17.1–4

Tobiasse devoted his entire suite to the celebration of Shavuot, also known as the Feast of Weeks, commemorating the giving of the Ten Commandments and the agricultural harvest.

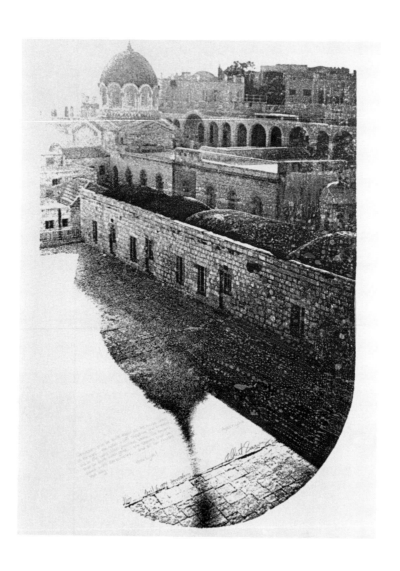

ALBERT GARVEY
b. 1932

Printmaker, sculptor. Born in the United States. Studied at the Chicago Academy of Fine Arts; Art Institute of Chicago; University of California and Otis Art Institute, Los Angeles; School of Decorative Arts, Paris; studio of Nicolai Fechin, Los Angeles.

We Are the Wall Itself, 1974

24 color screenprints on Rives BFK paper; 76.2 × 56.2 cm (30 × 22⅛ in.); no. 1 of 100. Each print signed, dated, and titled. Printed by artist; chopmark: © Albert Garvey 1974. Commissioned and published by the Judah L. Magnes Museum, 1974.

Gift of the artist. 75.10

Garvey based his portfolio on photographs he took while visiting Israel for three months. Written at the bottom of *Jerusalem* is the following:

Jerusalem shall be built again as His house unto all the ages . . .
 the gates with sapphire and emerald, and all the walls
with precious stone. The towers shall
be built with gold, . . . and all her
houses shall say . . . Hallelujah!
Tobit 13:16–18

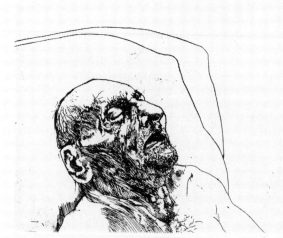

S. Ahrly

SIGMUND ABELES

b. 1934

Graphic artist, printmaker, sculptor, professor of art. Born in New York City. Studied at Pratt Institute, New York; University of South Carolina; Art Students League, New York; Skowhegan School of Painting and Sculpture, Maine; Brooklyn Museum School of Art; Columbia University. Taught at Wellesley College, 1964–69; Boston University, School of Fine Arts, 1969–70; University of New Hampshire, 1970–87, named Professor Emeritus, 1987.

Toward the End, 1969

12 etchings from a portfolio of 13 etchings on Rives BFK paper; 37.9 × 28 cm (14⅞ × 11 in.); no. 5 of 65. Each print plus title page signed by artist. The entire portfolio was executed by Impressions Workshop, Boston: etchings printed by Robert Townsend; type hand set in Garamond and printed by Shirley Borella; portfolio bindings designed by Ivan Ruzicka. Published by Aquarius Press, Baltimore.

Gift of Stewart and Beverly Denenberg. 84.35.3.1–12

"These plates were inspired and begun during my father's last days and dedicated to his memory."

Sigmund Abeles

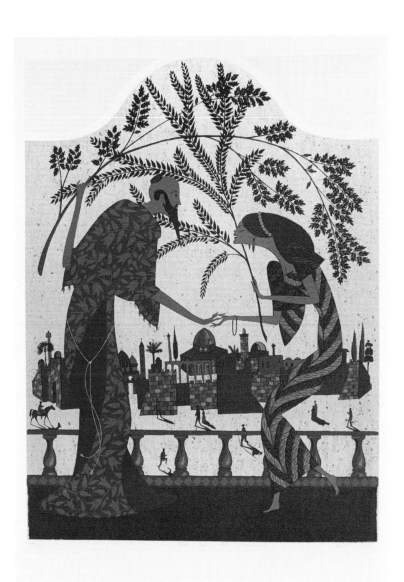

SHLOMO KATZ

b. 1937

Graphic artist, illustrator. Born in Poland. To Israel, 1945. Studied at Avni Academy of Art, Tel Aviv, 1960; School of Fine Arts, Paris, 1962–64.

Passover Portfolio, 1982–83

10 color screenprints on Arches 270 GR paper; 70 × 53 cm (27 ½ × 20⅞ in.); no. 77 of 300. Each print signed, numbered, and titled. Watermark: Strictly Limited Editions, San Francisco, California. Printed by Atelier Har-El, Tel Aviv, July 1982–October 1983. Published by Strictly Limited Editions, San Francisco. Two pages of explanatory text. All color separations were produced by the artist. All screens used for each image were canceled.

Gift of Alan and Carol Fibish. 85.37.1–10

The customs and stories of Passover are the subjects of Katz's decorative and oriental-inspired serigraphs. *Next Year in Jerusalem* refers to the blessing that ends the Passover service.

INDEX OF ARTISTS